Welcome to Corgis on Vacation!

We've included the
following fantastic destinations:

Double Decker Bus, London, England
Saint Basil's Cathedral, Moscow, Russia
Taj Mahal, Agra, India
Cinque Terre, Italy
The Painted Ladies of San Francisco, California, USA
Bora Bora, French Polynesia
Machu Picchu, Peru
Tulips in Amsterdam, Netherlands
Dunrobin Castle, Scotland
Scuba Diving, Great Barrier Reef, Australia
Park Guell by Antoni Gaudi, Barcelona, Spain
Gondolas in Venice, Italy
Daigo-ji Temple, Kyoto, Japan
Elia Beach, Mykonos, Greece
Egyptian Pyramids, Cairo, Egypt

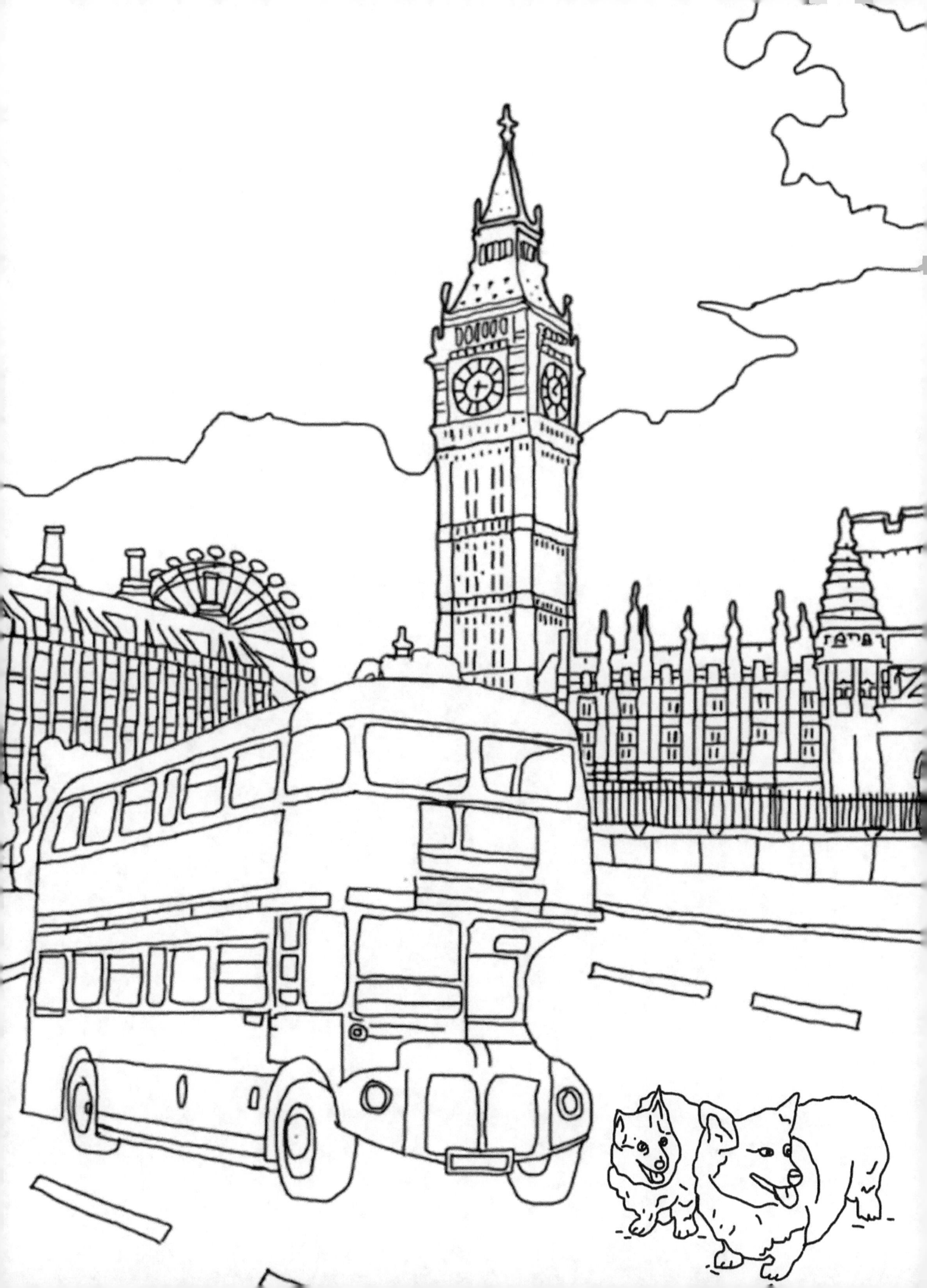

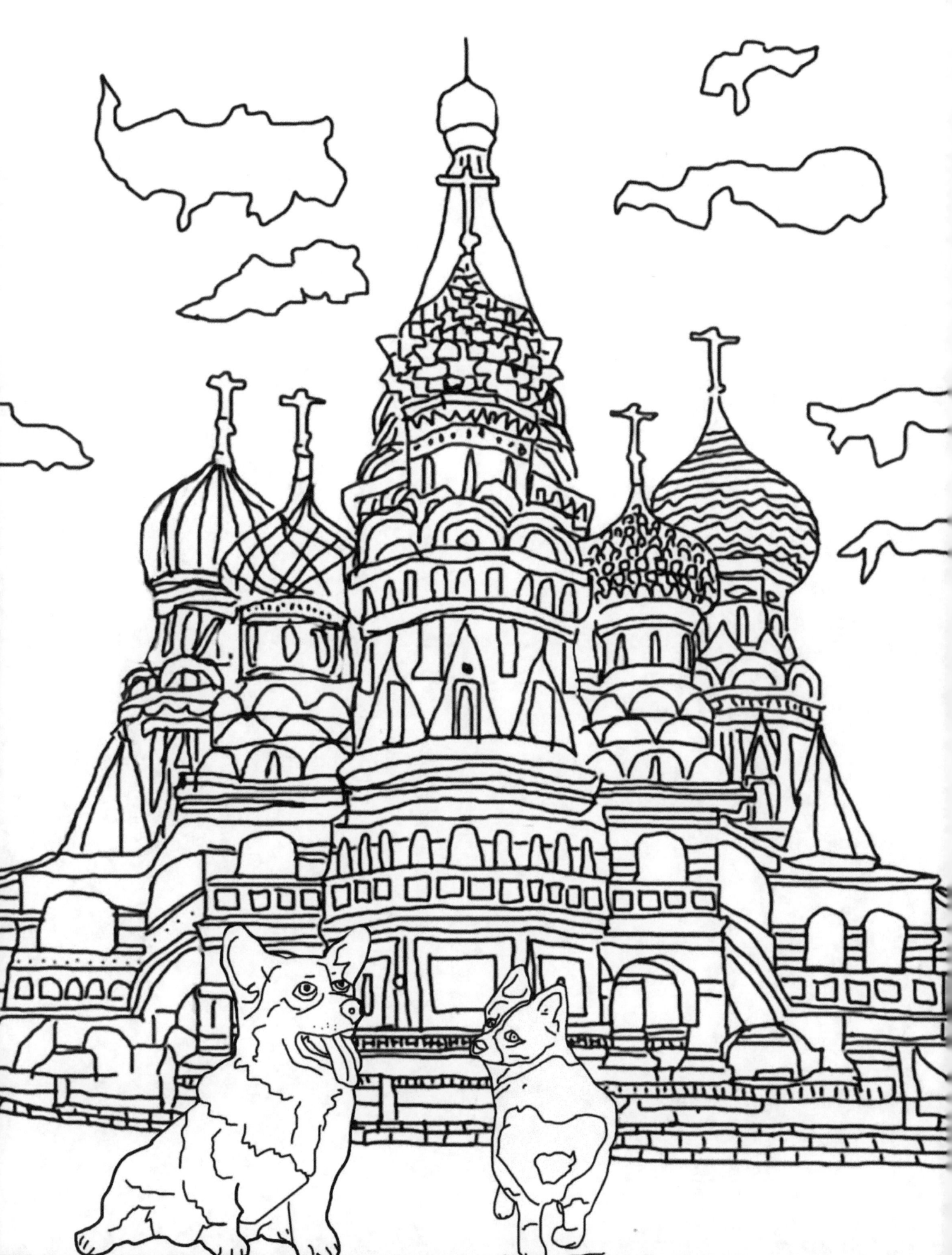

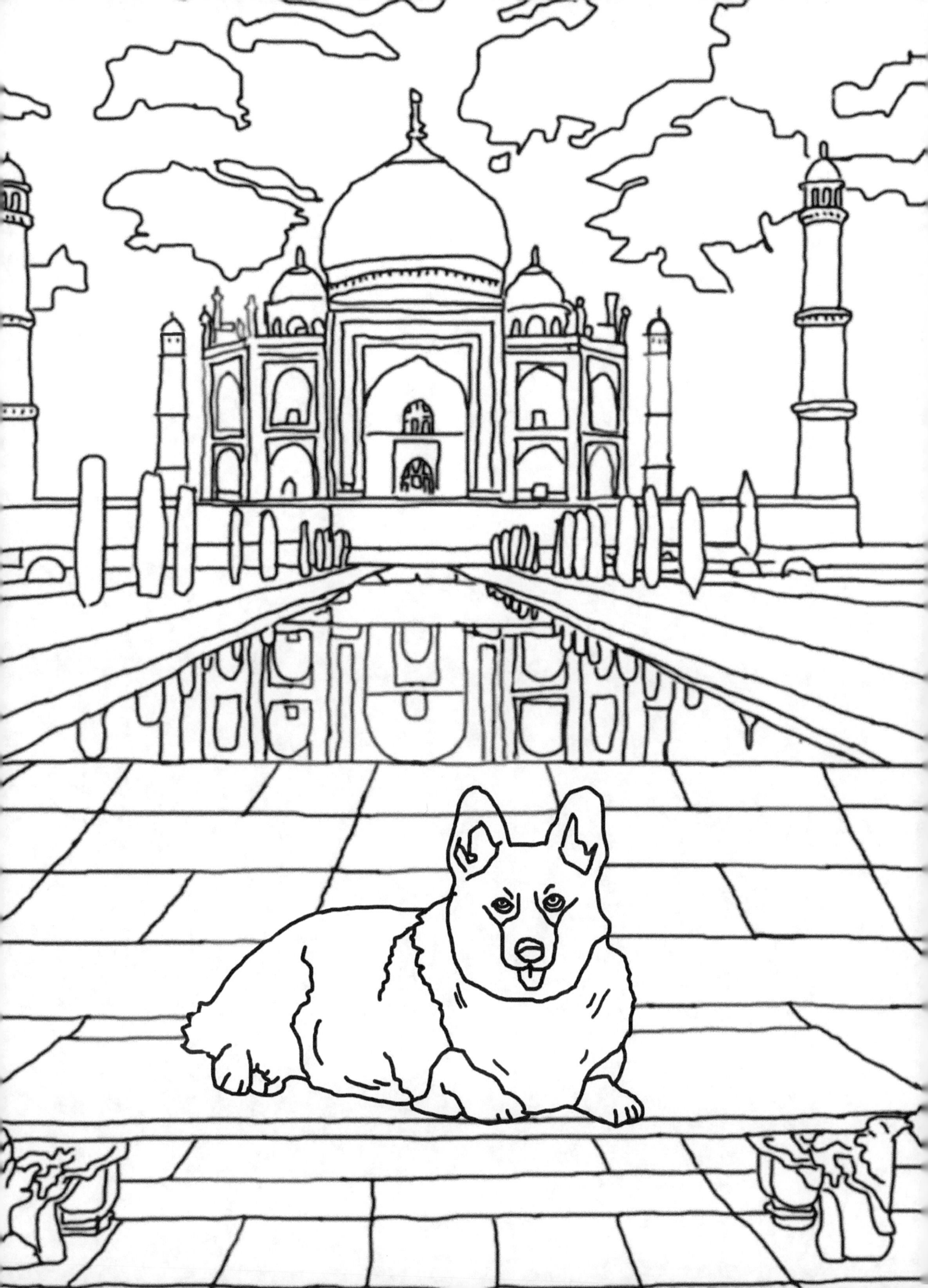

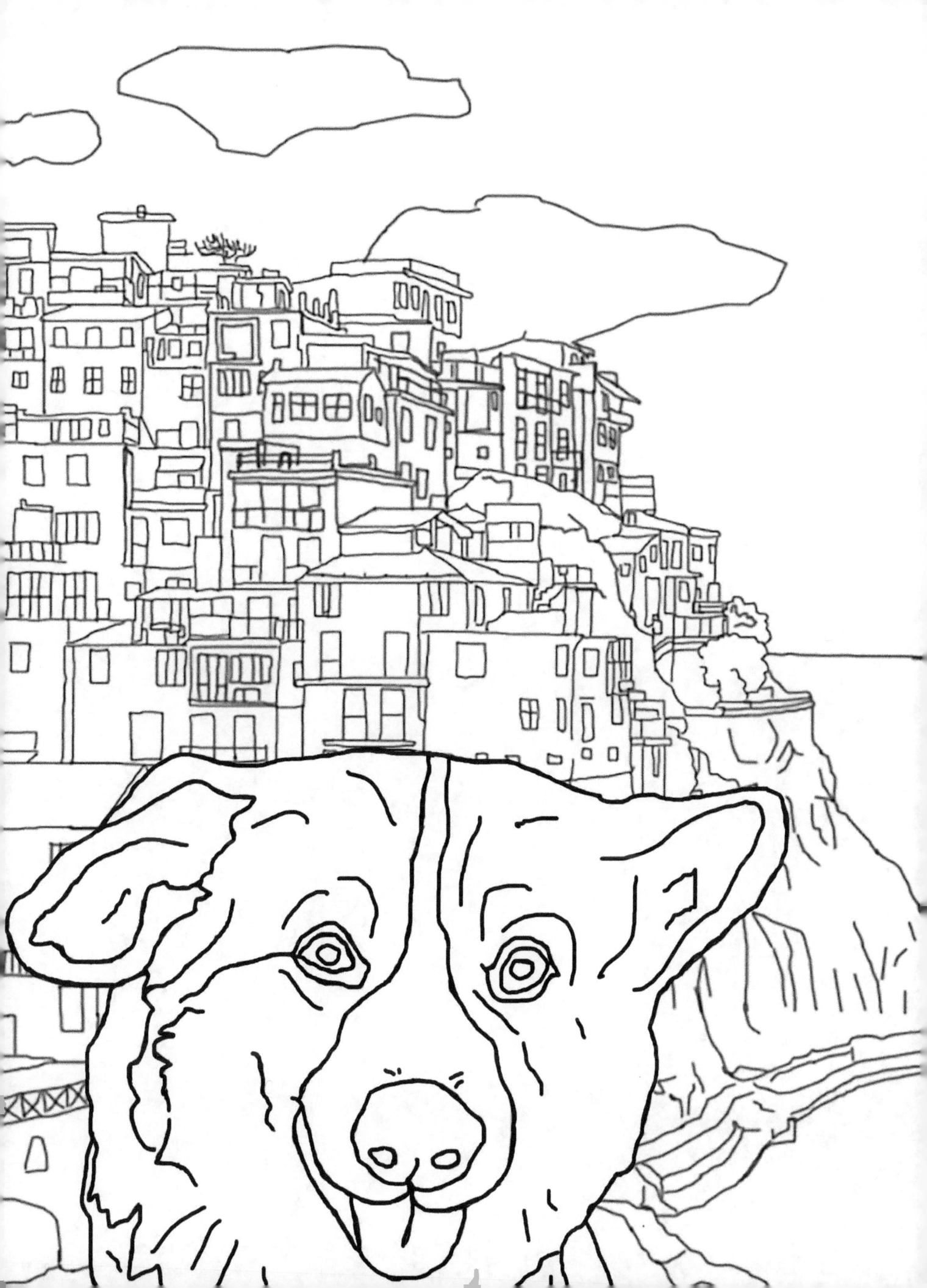

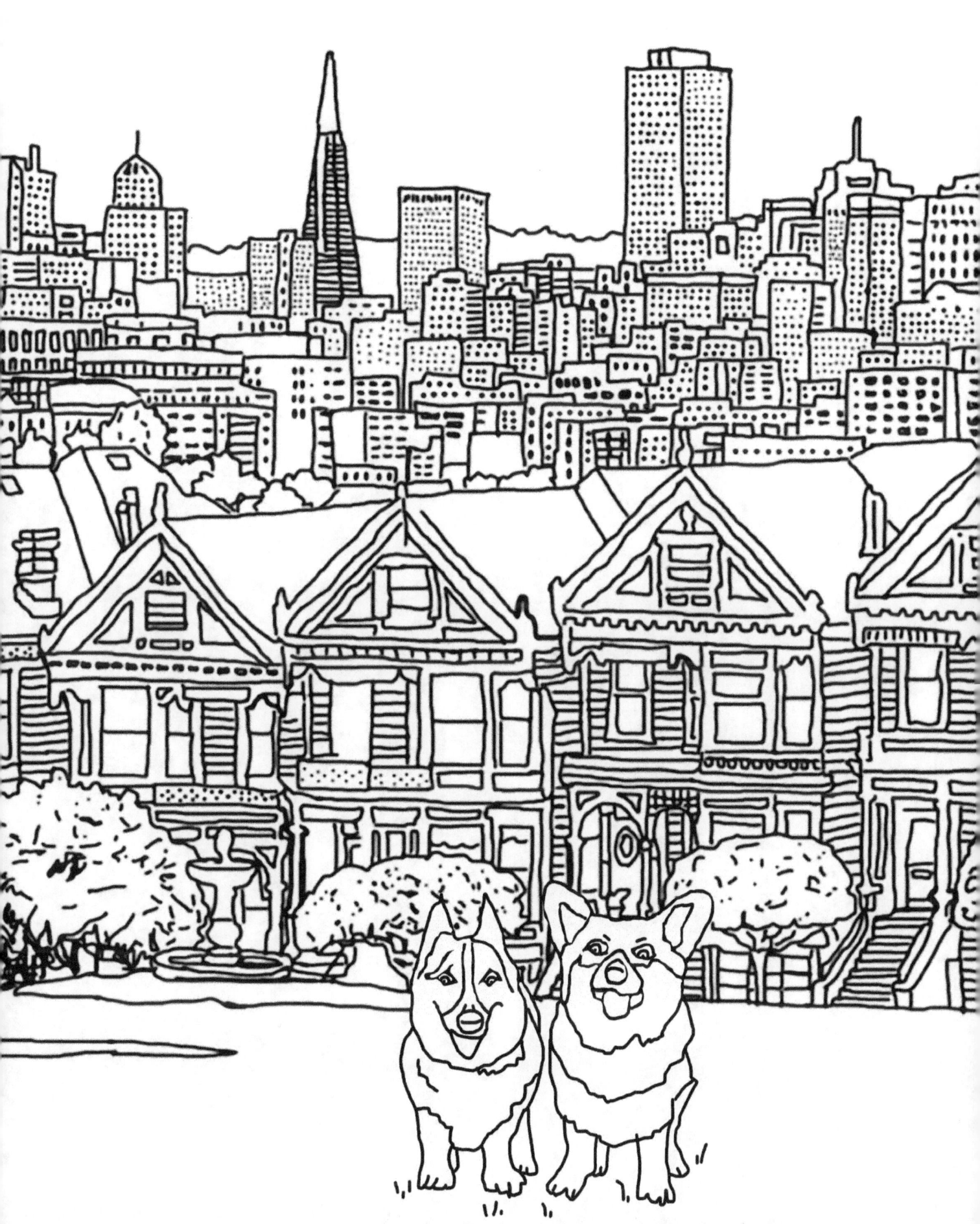

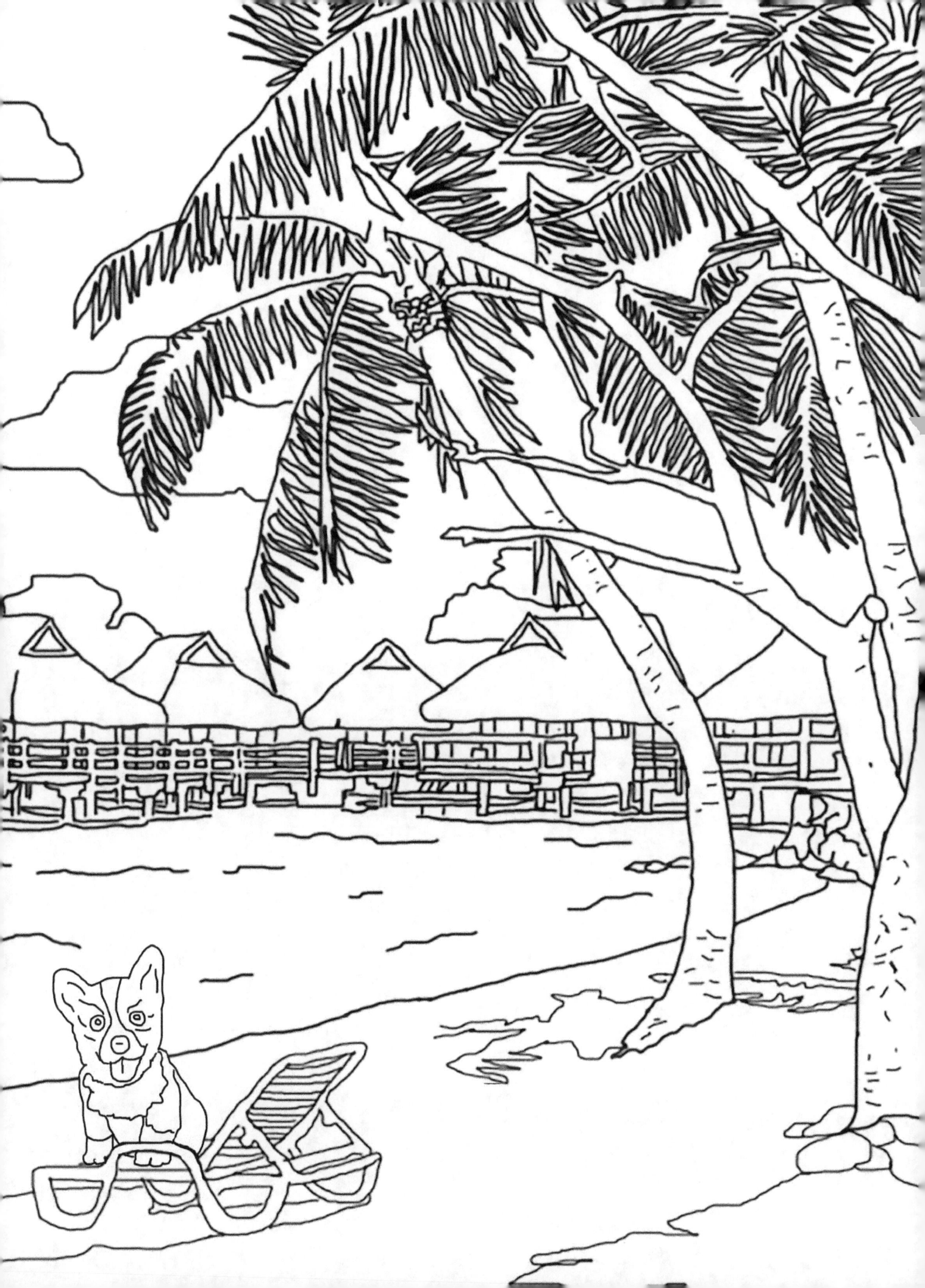

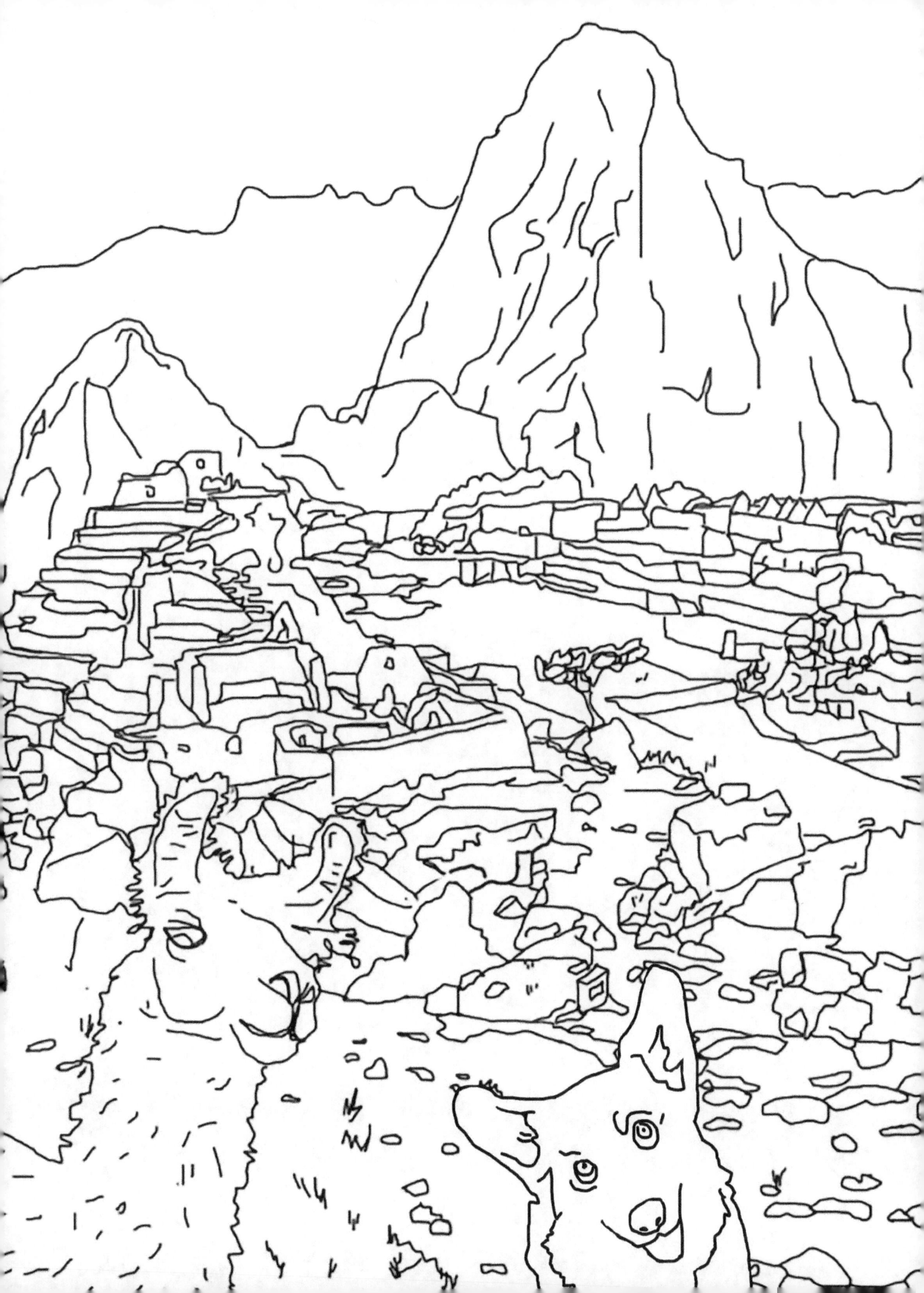

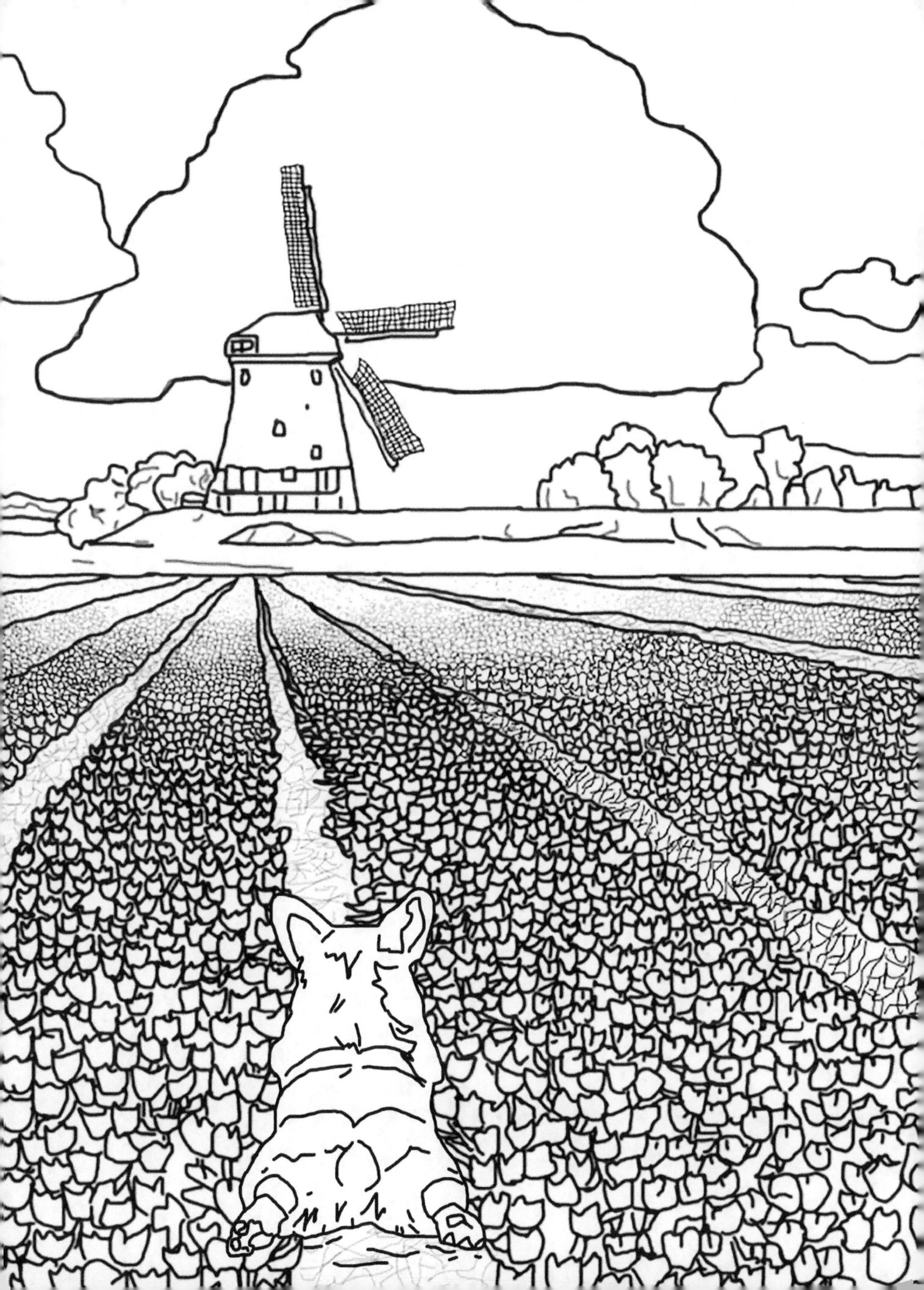

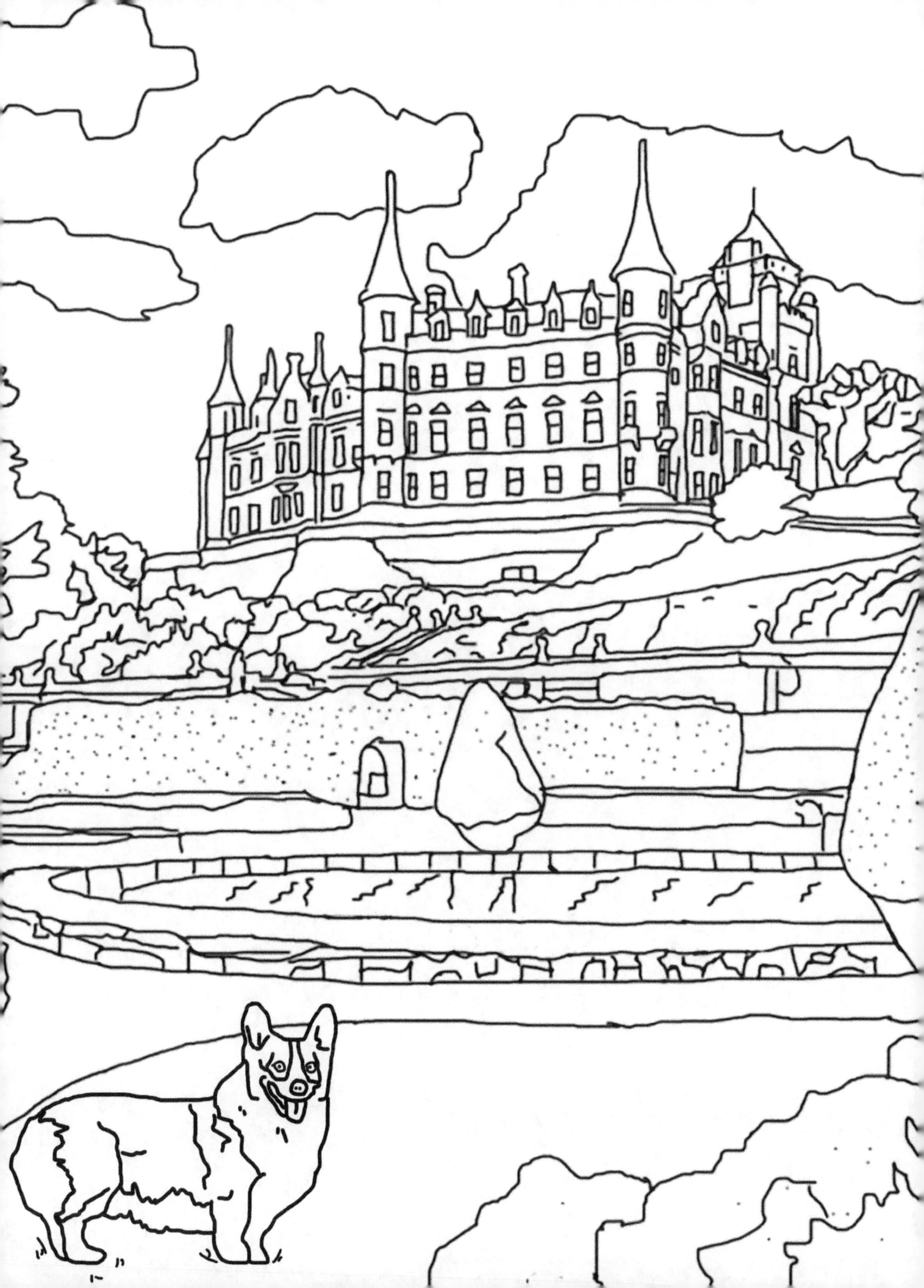

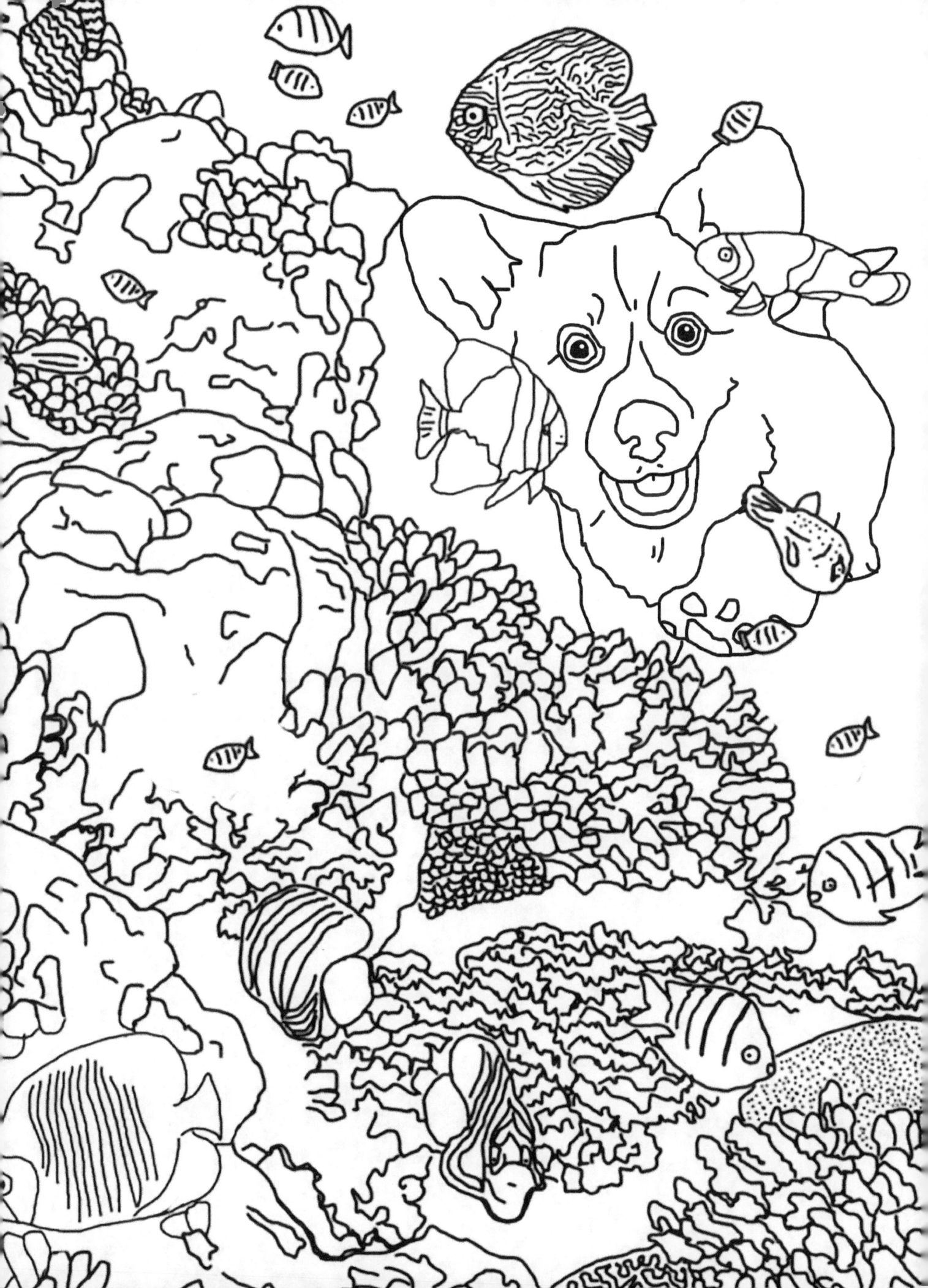

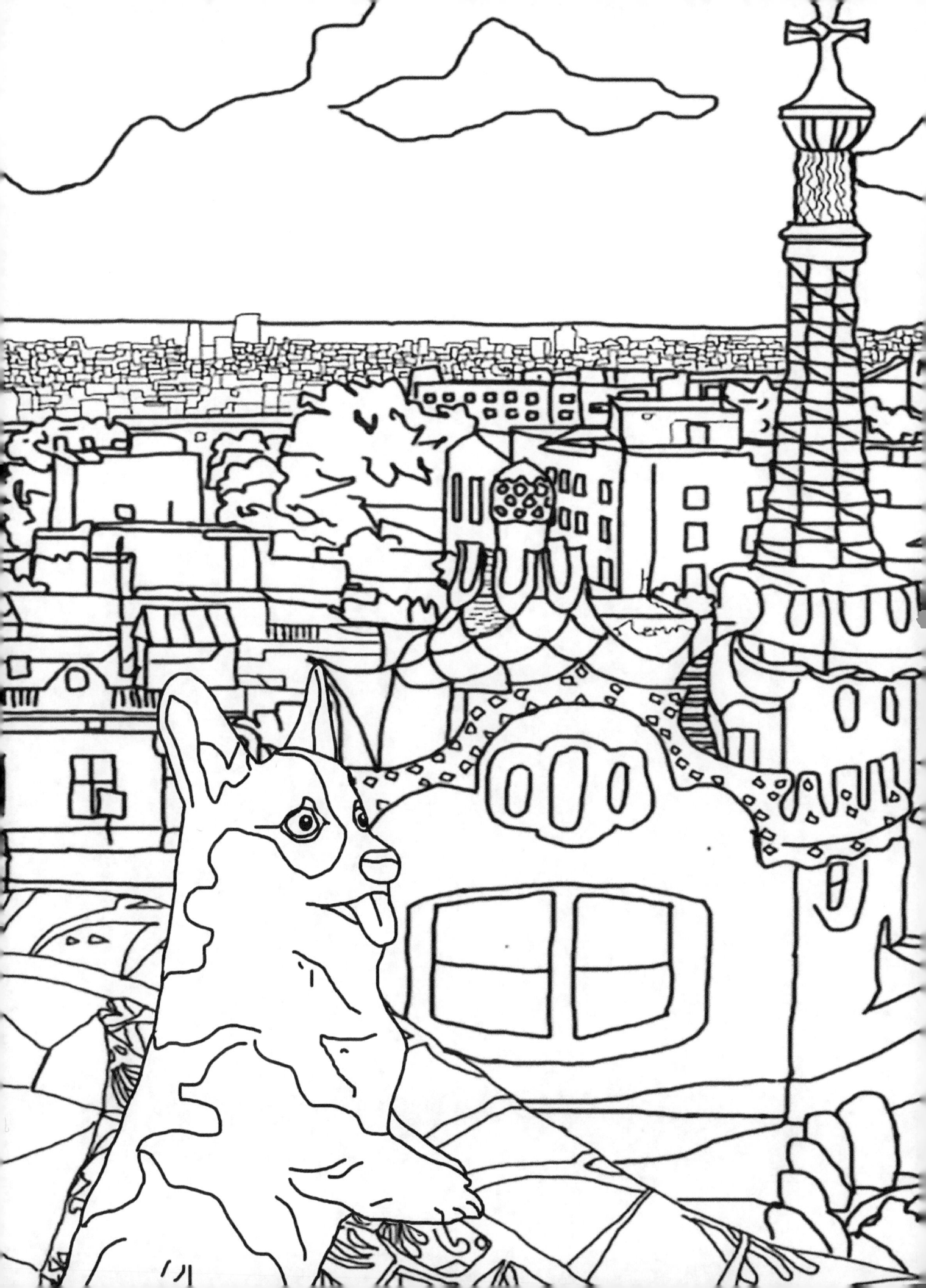

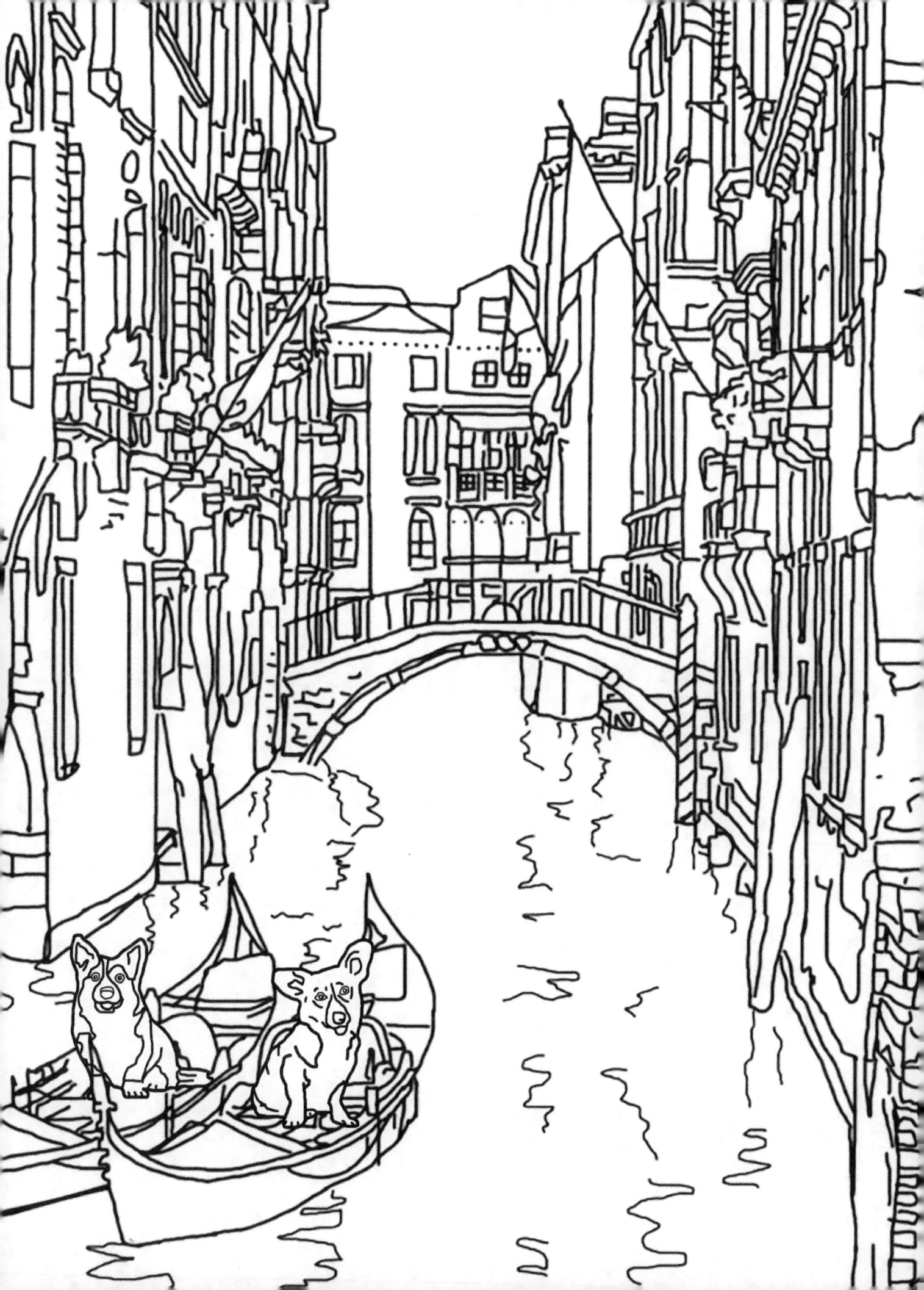

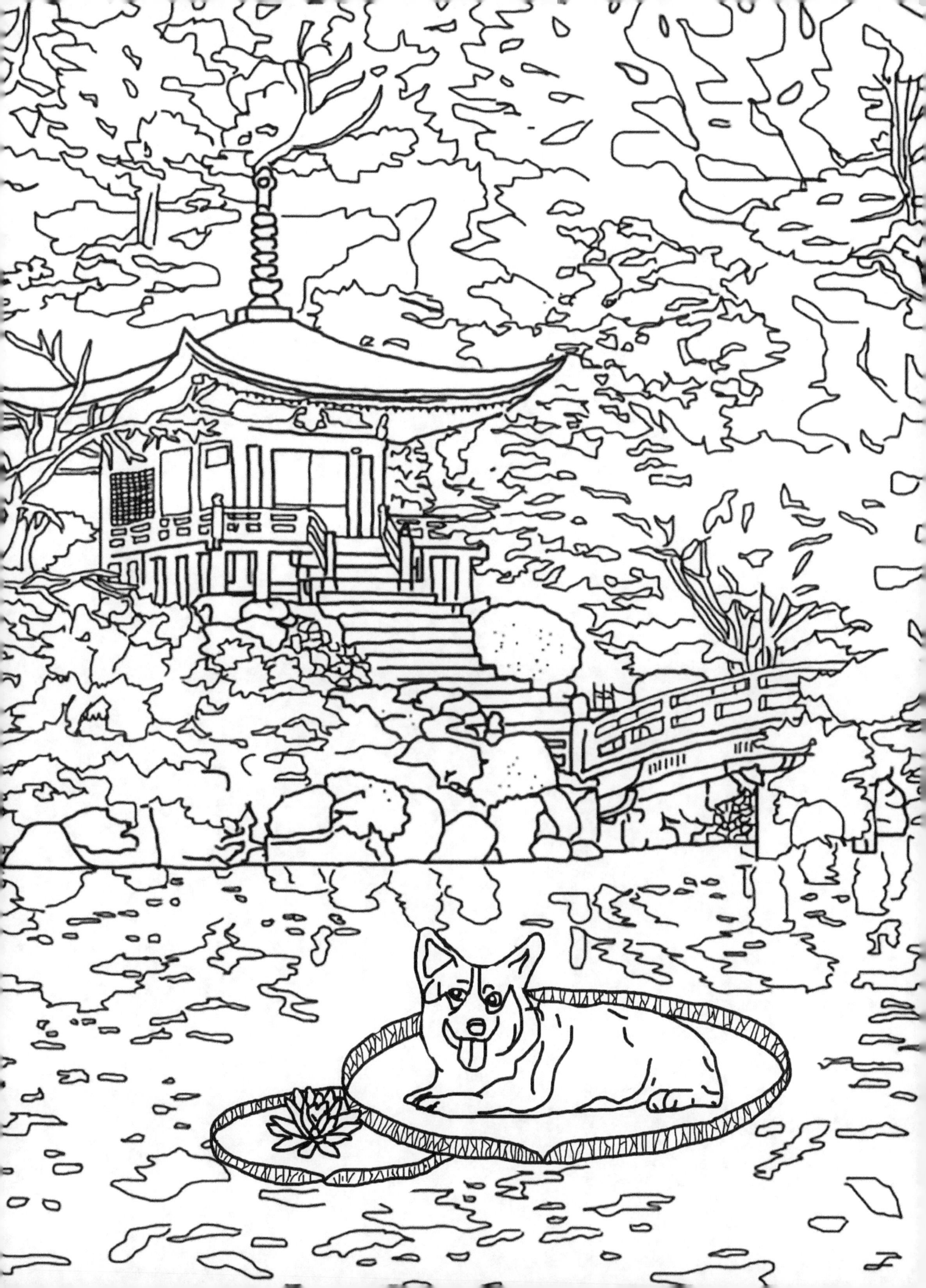

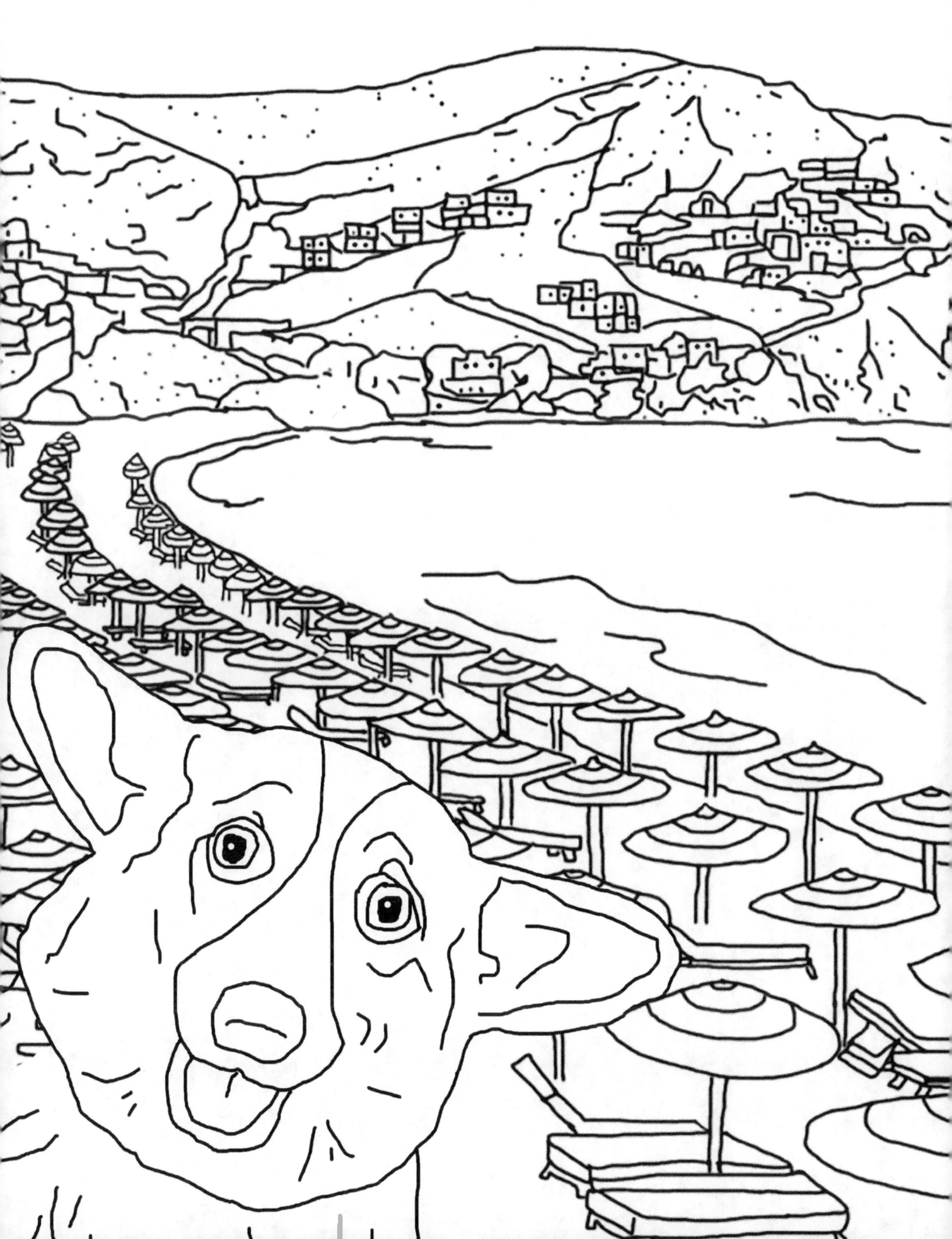

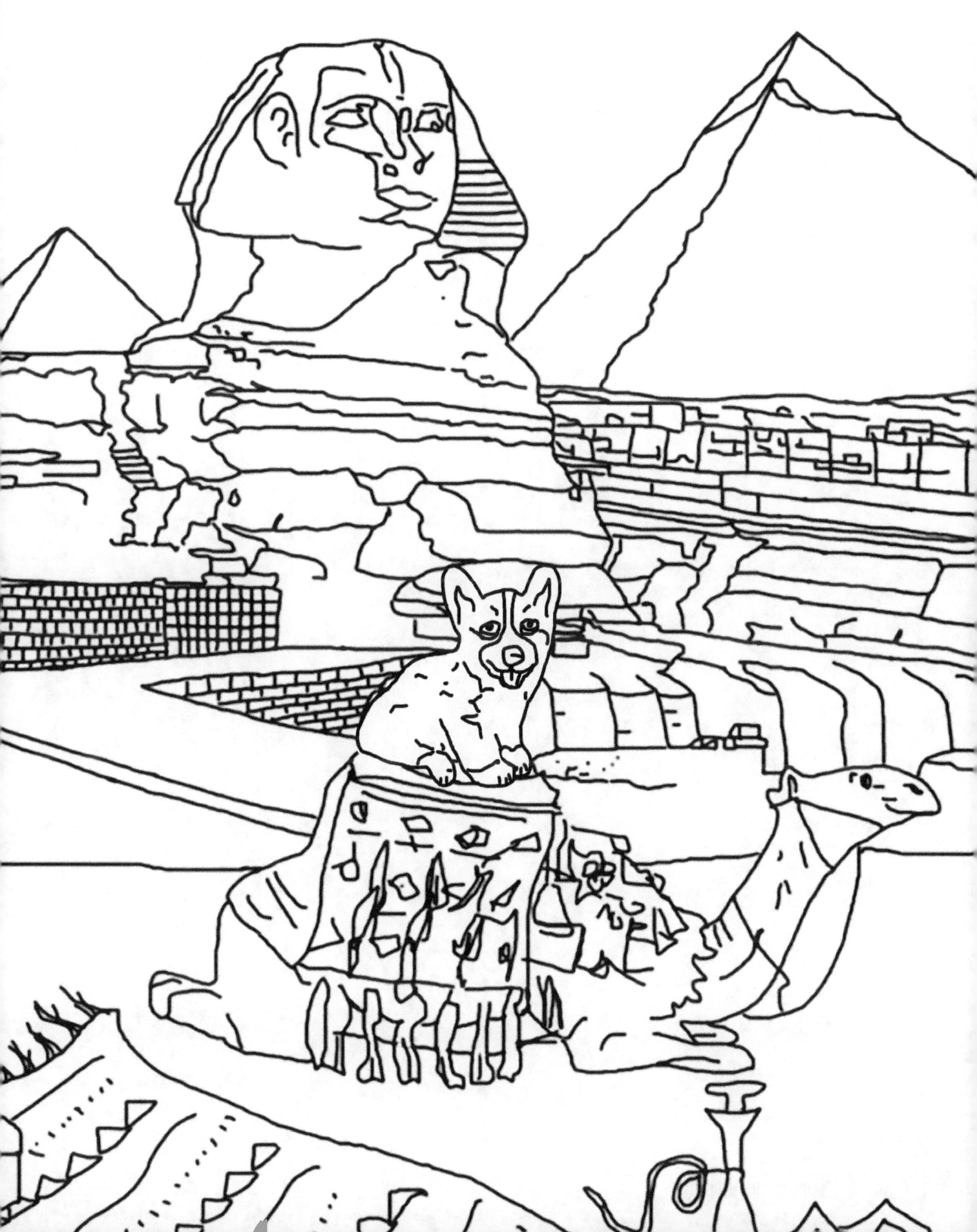

www.ingramcontent.com/pod-product-compliance
Lightning Source LLC
Chambersburg PA
CBHW080530190526
45169CB00008B/3112